HIROSHIMA
remembering 1945 & 1958

Virginia Moffat Khuri

© 2017 by Virginia Moffat Khuri. All Rights Reserved. Printed in the United States of America.

Hiroshima, remembering 1945 & 1958

No part of this book may be reproduced, stored in a retrieval system, or transmitted by any means, electronic, mechanical, photocopying, recording, or otherwise, without written permission from the author except in the case of brief quotations embodied in critical articles and reviews.For information address Between Lines Books & Arts, betweenlinesbooksandarts@google.com
Publisher's Mailing address: Between Lines Books, 33 Barnard Road Granville, Massachusetts 01034.

All photographs in this book are by Virginia Moffat Khuri.

Published by Between Lines Books & Arts in 2017.

ISBN: 978-0-9966659-6-4

Library of Congress Catalog Card Number: 2017945540

This book is printed on acid-free paper.

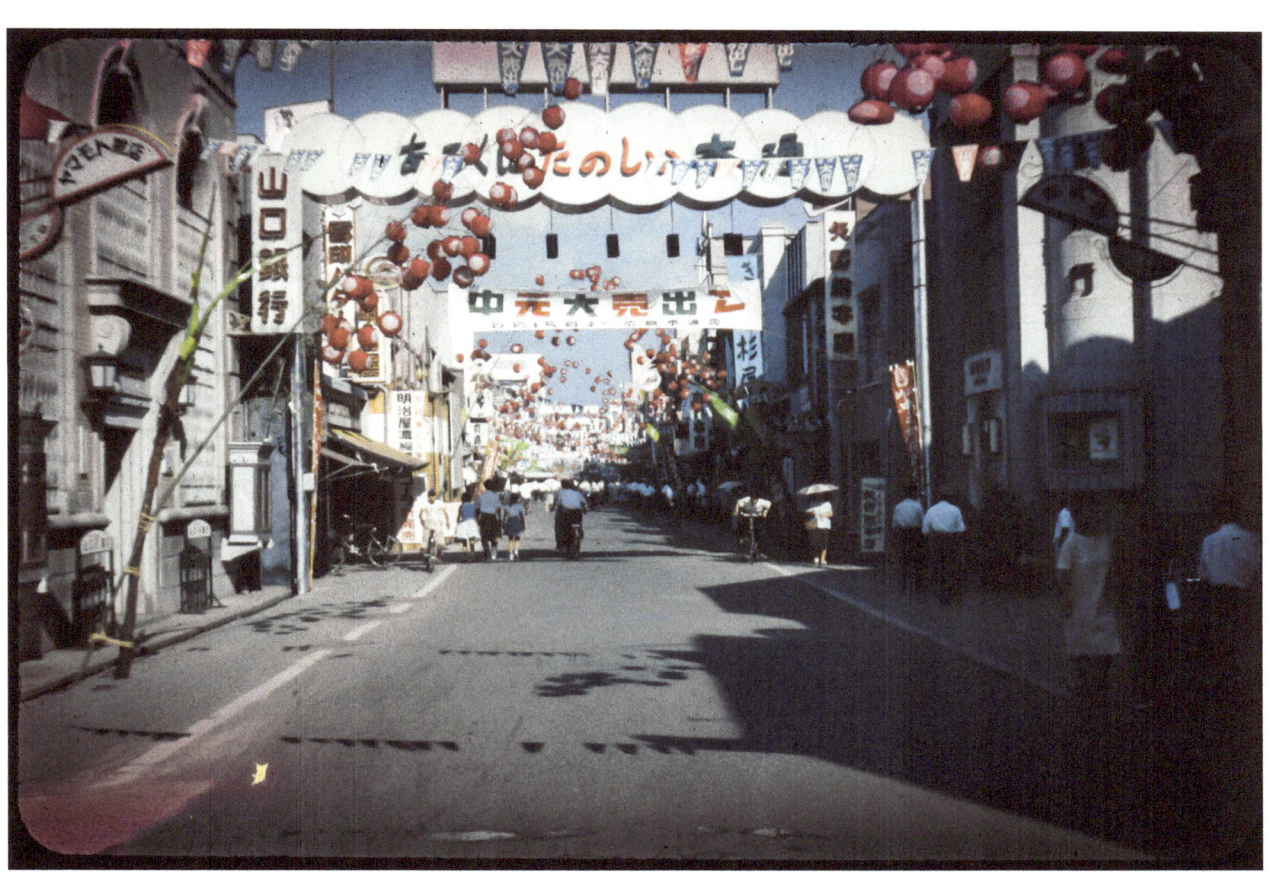

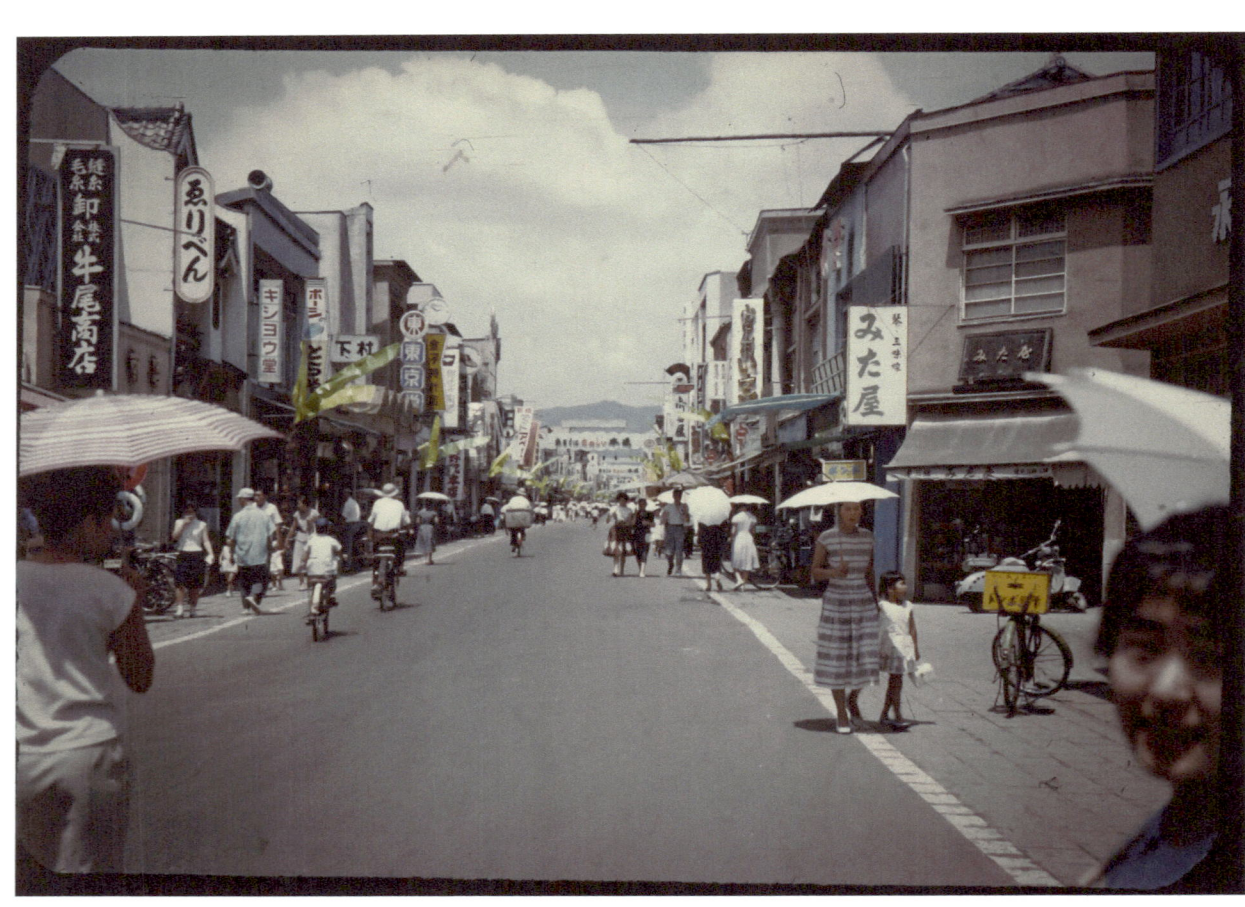

In Memory of

Dr. Jisuke and Mrs. Masako Nakazawa

and Dell and Howard Moffat

and with thanks to

The American Field Service Intercultural Program

for giving me this experience,

and for

Chikako Nakazawa Kamitsuna and her Grandchildren:

Haruka, Takefumi, Hana and Mia

and for

my Grandchildren: Anthony, Helen, Andraos, and Shanna

HIROSHIMA
remembering
1945 & 1958

On August 6, 1945 the United States of America dropped an atomic bomb on the city of Hiroshima, Japan. It was an experiment that instantaneously changed the world. It is credited with ending a brutal war.

Thirteen years later I spent the summer in the city as one of 20 American Field Service exchange students, the first to be sent to Japan. I lived with the family of Dr. Jisuke and Masako Nakazaawa. He was a medical doctor who after the war chose to practice medicine in Hiroshima. His daughter, Chikako, became my 'Japanese sister' and we have remained close over the years.

Little evidence remained of the complete physical destruction of the city which had been quickly rebuilt, but I experienced a shock on seeing evidence of the human cost to the city's inhabitants: on display in the Memorial Museum; during a tea given for me by the Hiroshima Maidens (women who had been to the US for plastic surgery for severe burns); and in a conversation with a 13-year-old girl in hospital dying of leukemia as a result of radiation exposure in infancy who wished me to teach her American slang.

The human cost of the atomic bomb is one that is ignored at our peril, because the lesson is not that the use of the weapon ended a war, but that it ushered in an utterly new and horrifically dangerous era that we are still in.

On August 6, 1958 I stood with my Japanese sister before the Children's Memorial in the Hiroshima Peace Park to deliver a

message to the youth of Japan. I ended my brief statement with these words:

> I think in this respect that the city of Hiroshima has the special privilege of being able to show the world the consequence of an atomic war. Of course in modern Hiroshima few visible reminders of the war remain, but since memory sometimes fades, the stark outlines of the Gem-Baku Dome will for a long time be a constant reminder. Then too, this Memorial Park is something to be proud of. It is my hope that the world will regard these monuments for peace and remember them.

I still cannot believe that the world has not listened to the message of Hiroshima and Nagasaki and that nuclear weapons continue to proliferate and become even more powerful. True, we have not yet had a nuclear war, but the threat increases while the consequences remain unspoken. Indeed, the true nature of the weapon was kept from the American public for years; it wasn't until 1952 that the first images of the day were made public. A visit to Hiroshima should have become a prerequisite to holding high office worldwide.

Following are scans from slides I made with an old prewar camera that belonged to my father. They were badly stored for 50 years and I almost discarded them until I realized that perhaps I could use the distressed images to illuminate the terrible human suffering caused by Hiroshima's atomic bomb.

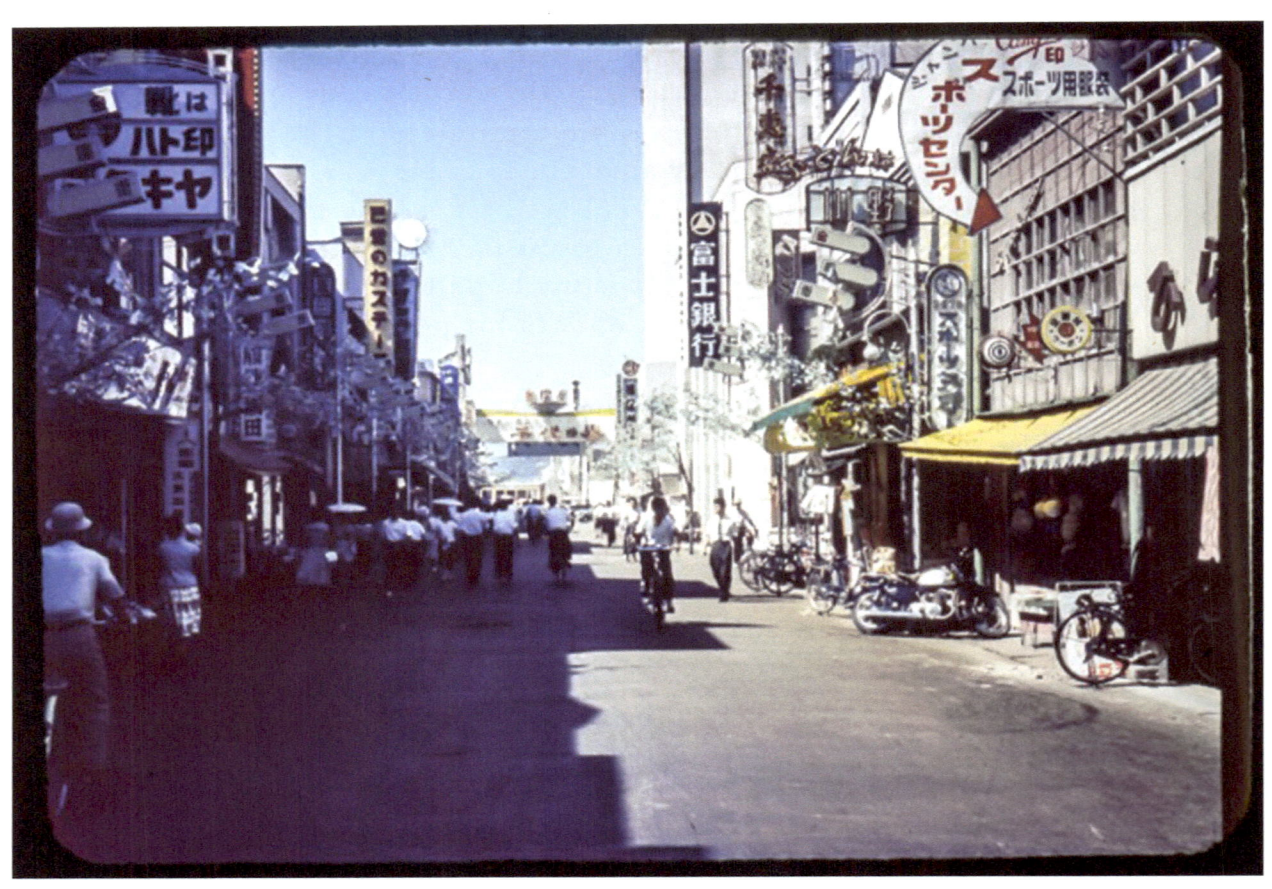

On a cloudless, blue-sky morning, hot and humid, an American airplane, the Enola Gay, dropped a bomb, code named 'Little Boy' on the center of the city of Hiroshima. It seemed a morning like any other, and at 8:15 the 350,000 inhabitants were going about as usual: men to work, housewives to shop, children to school. Eighty percent of the population were civilians with the military stationed in barracks on the outskirts of the city. All would have seen the large bomber overhead, but thought it was a lone reconnaissance plane. Although most other cities suffered the devastation of massive fire bombing, Hiroshima so far had been spared. So there was no fear and no dash for cover, only curiosity about a parachute in the sky. Suddenly, a blinding flash of white light unleashed a hell on earth.

"The bomb instantly produced a temperature upwards of one half million degrees Fahrenheit. One ten thousandth of a second later, a fireball with a radius of 17 meters burned at a temperature of 3000 degrees farenheit.

"At the same time the extraordinary fireball created in the atmosphere an intense shock-wave resulting in unprecedented destructive power. The heat from the ball itself wantonly ignited both human beings and buildings. . . the atomic bomb produced terror and then most terrible destruction through radiation. This weapon with a single explosion in a single moment turned a broad expanse into ruins." [1]

John Whittier Treat

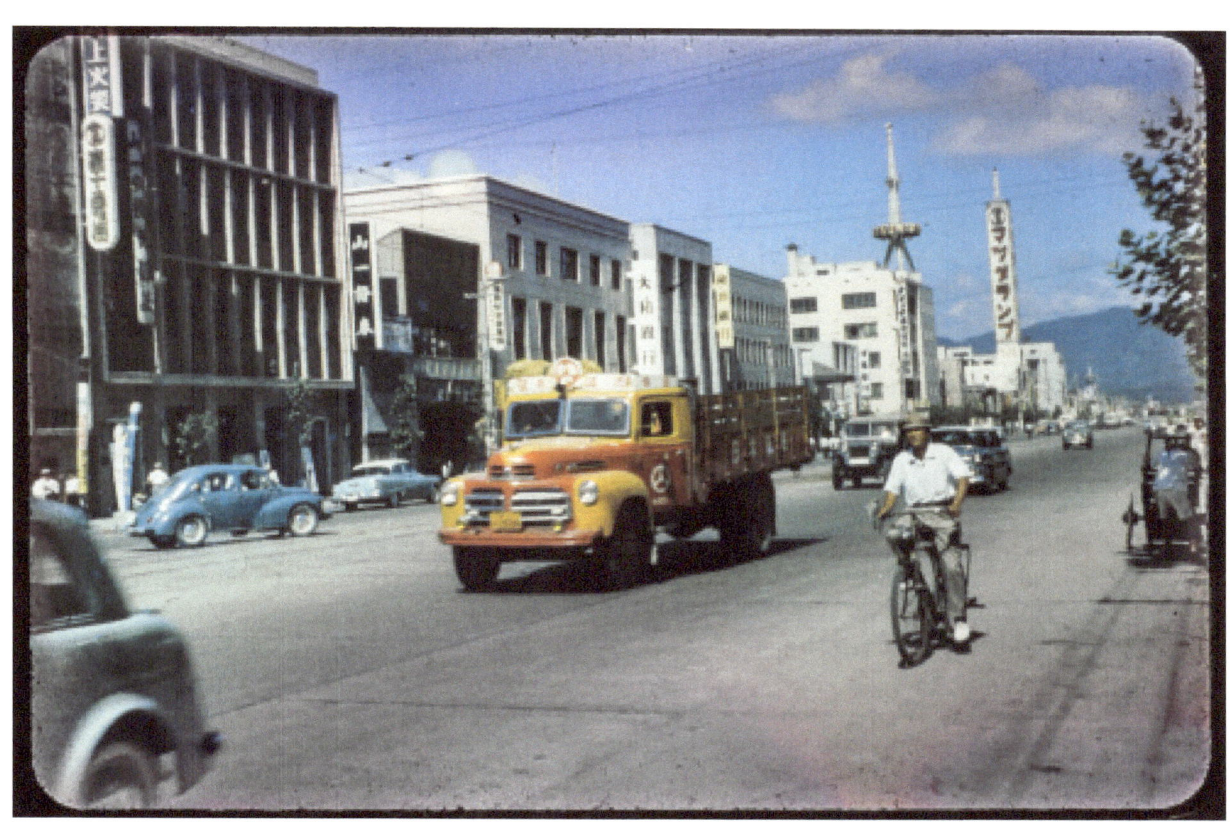

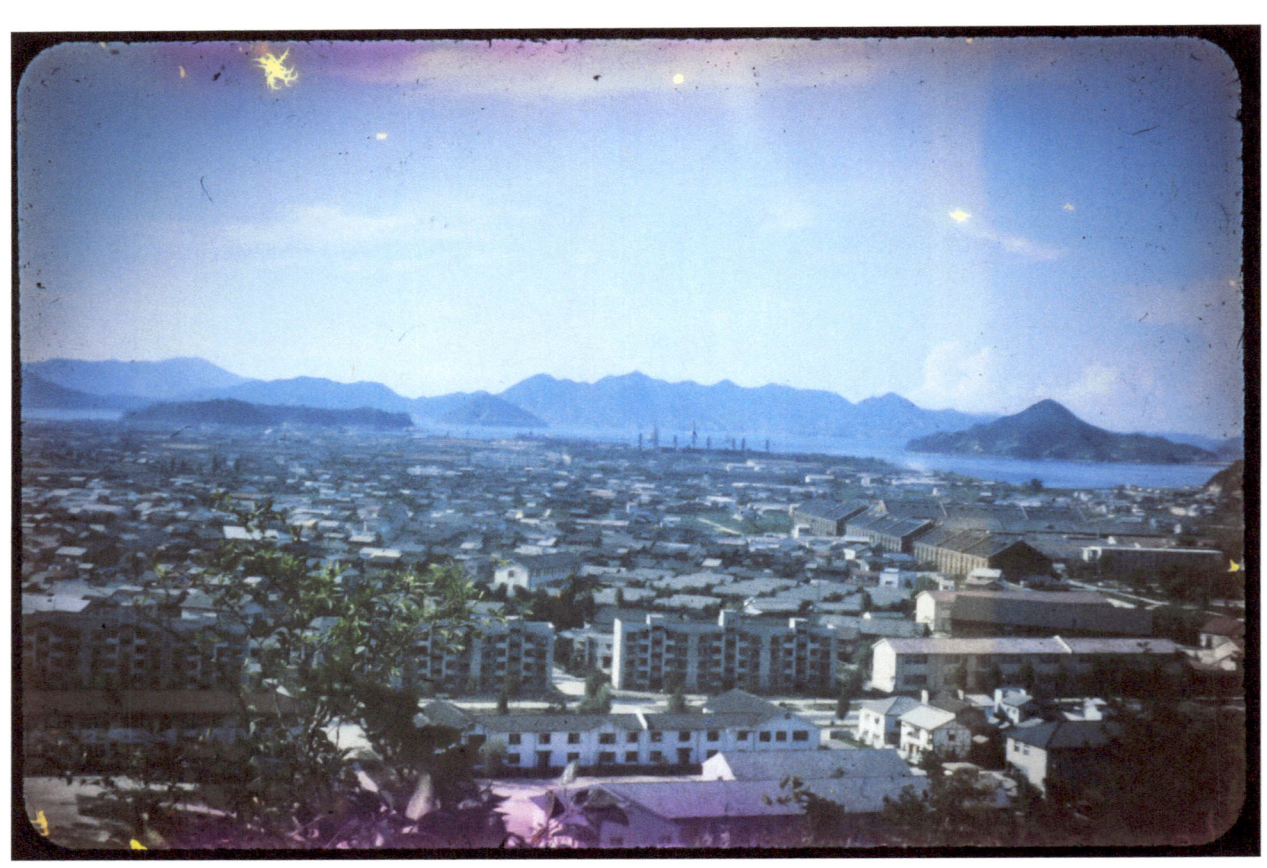

 The bomb was set to explode 1,900 feet above the ground for maximum destructive effect. A searing white fireball, hotter than the surface of the sun, sent its radiant heat out in all directions at twice the speed of sound. People within a one mile radius of the center were instantly carbonized; those further away suffered terrible burns. The heat of the explosion literally melted the skin of all who weren't sheltered from the rays and most people were left naked, their clothing ripped away by the shock-wave.
 Some lived.

The bomb laid waste to the city. Of 200 doctors in the city, 90 percent were killed or injured. Of 45 hospitals only three were usable. There was no help. No medicine. No pain relief.

The terror of these first few days then became the fear and horror of a mysterious new illness marked by vomiting, fever, purple sores and hair loss. We now know it as radiation poisoning, but then even the US government did not understand it: a few experiments had been done with rabbits. After two years the Atomic Bomb Casualty Commission was created to observe and study, but not to treat, the illness; continuing until today, it has become the longest medical study in the world.

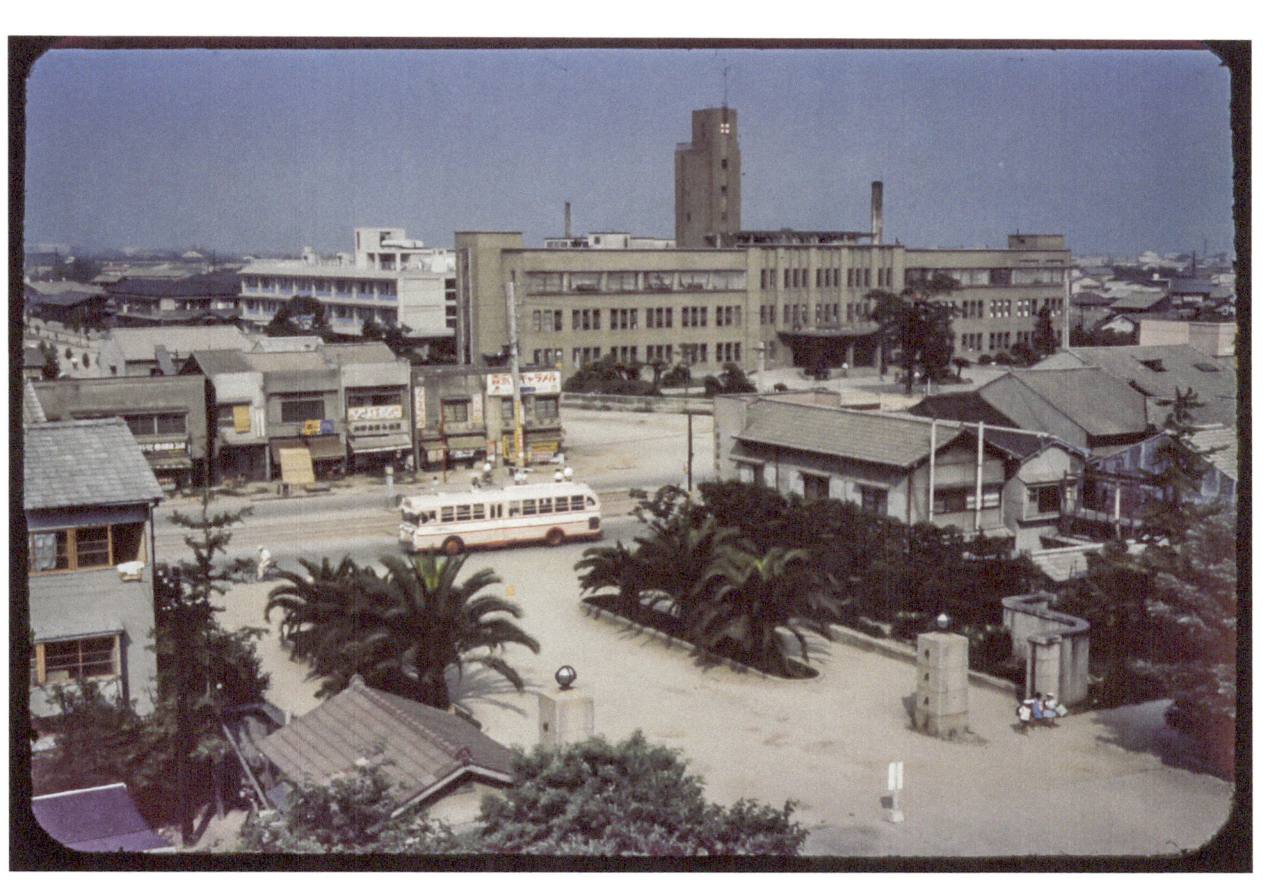

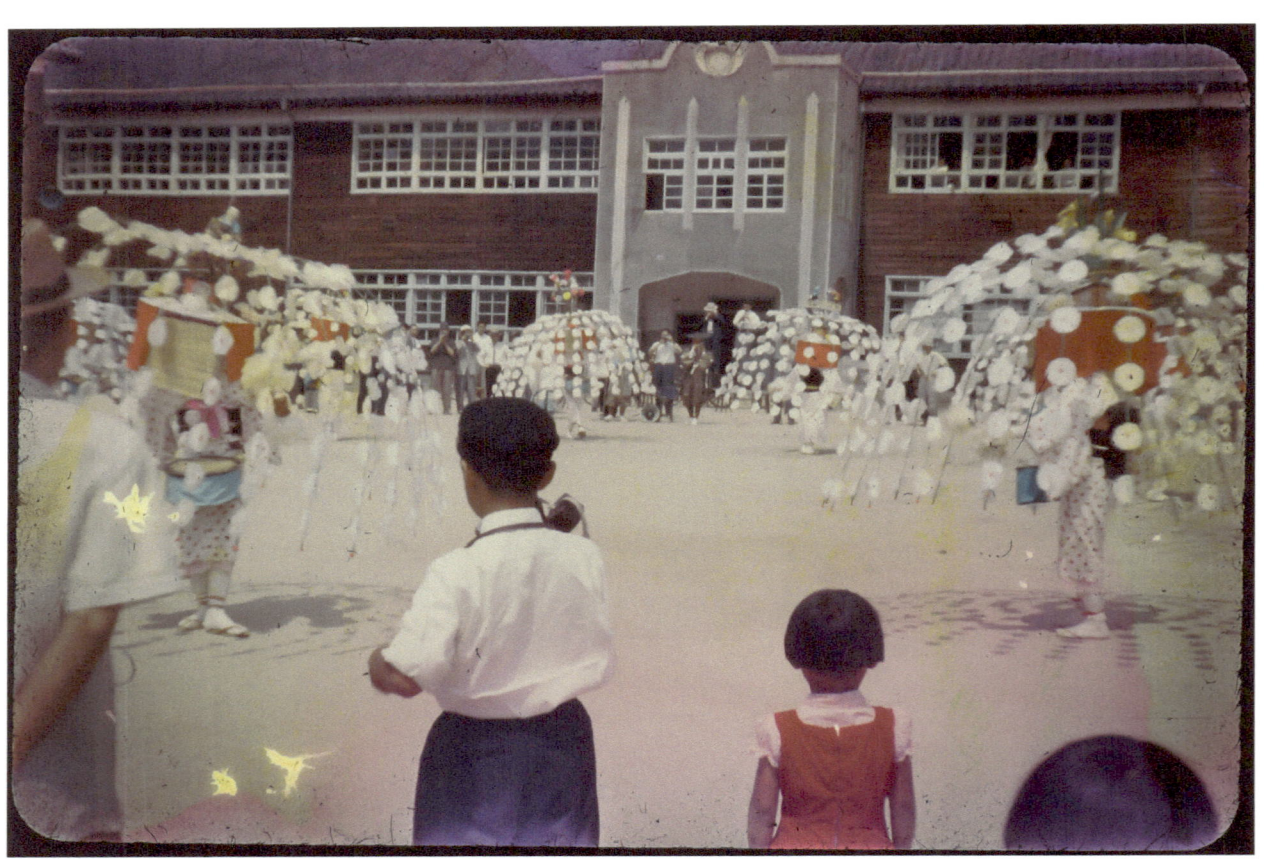

The Shock-wave following the heat ray flattened over 60,000 buildings in less than 10 seconds. There was heavy damage for three miles in all directions with people dead and dying beneath wooden beams and heavy ceramic roof tiles. Many thousands survived the initial blast but were trapped in the wreckage of their homes and schools. Then the fires began, simultaneously springing up all over the city. These flaming points of light, seen from the Enola Gay were fanned by gale force winds to create a massive vortex with walls of fire that raged across the city.

Tadao Watanabe in 1957, told the Los Angeles Times about the atomic bombing of his city:

"There were 430,000 people in the city then. After the atomic bomb that killed 200,000, the population diminished to 130,000. Many left Hiroshima. But many are now returning. The city, tenth largest in Japan, has reached the 400,000 mark. Of these, 100,000 still report to the Atomic Bomb Hospital for periodical checks on the effects of radiation, (among them the Mayor who bears a scarred face). Two thousand are still hospitalized. Thirty-two deaths due to radiation disease have been reported so far this year. Twelve years after the blast, Hiroshima is about 50 percent recovered from the effects of the A-bomb. There are still many bridges to rebuild. There is a shortage of homes. Streets and sewers need attention. However, our schools have nearly all been rebuilt."

Tadao Watanabe, Mayor of Hiroshima

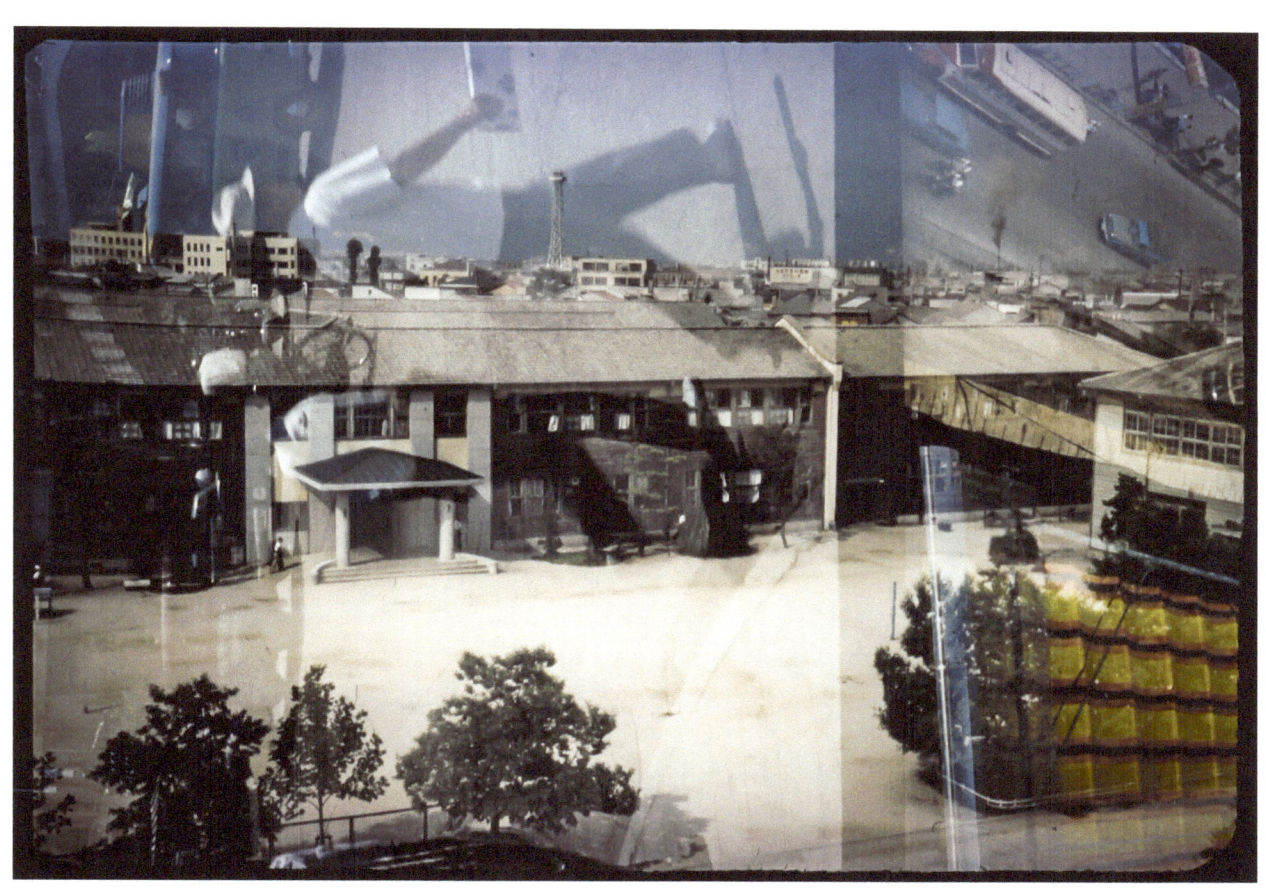

The City of Hiroshima Peace Declaration
August 6, 2007

"That fateful summer, 8:15, the roar of a B-29 breaks the morning calm. A parachute opens in the blue sky. Then suddenly, a flash, an enormous blast—silence—hell on earth.

"The eyes of young girls watching the parachute were melted. Their faces became giant, charred blisters. The skin of people seeking help dangled from their fingernails. Their hair stood on end. Their clothes were ripped to shreds. People trapped in houses toppled by the blast were burned alive. Others died when their eyeballs and internal organs burst from their bodies—Hiroshima was a hell where those who somehow survived envied the dead.

"Within the year 140,00 had died. Many who escaped death initially are still suffering from leukemia, thyroid cancer and a vast array of other afflictions.

"But there was more. Sneered at for their keloid scars, discriminated against in employment and marriage, unable to find understanding for their profound emotioal wounds, survivors suffered and struggled day after day, questioning the meaning of life.

"And yet the message born of that agony is a beam of light now shining the way for the human family. To ensure that 'no one ever suffers as we did' the hibakusha have continuouly spoken of experiences they would rather forget, and we must never forget their accomplishments in preventing a third use of nuclear weapons."

Tadatoshi Akiba Mayor of Hiroshima

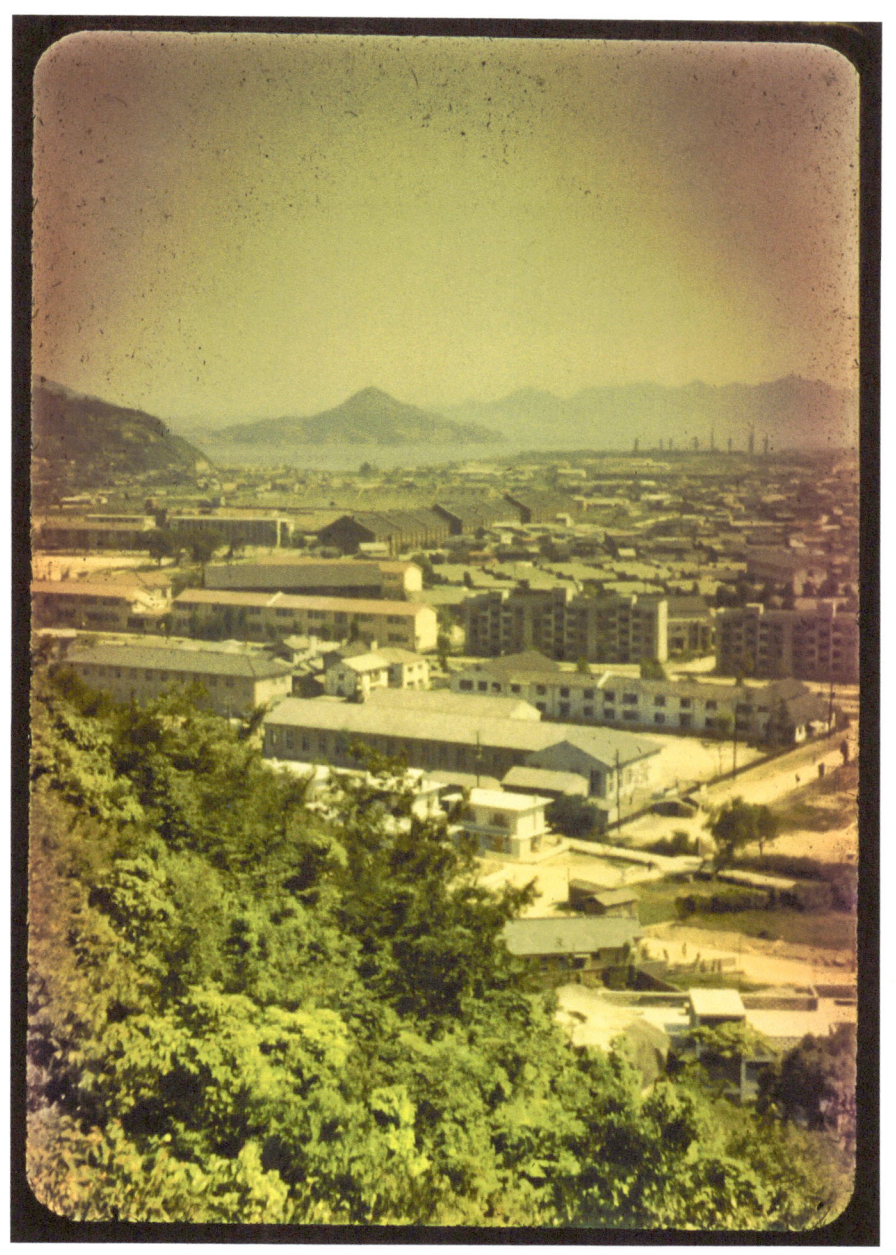

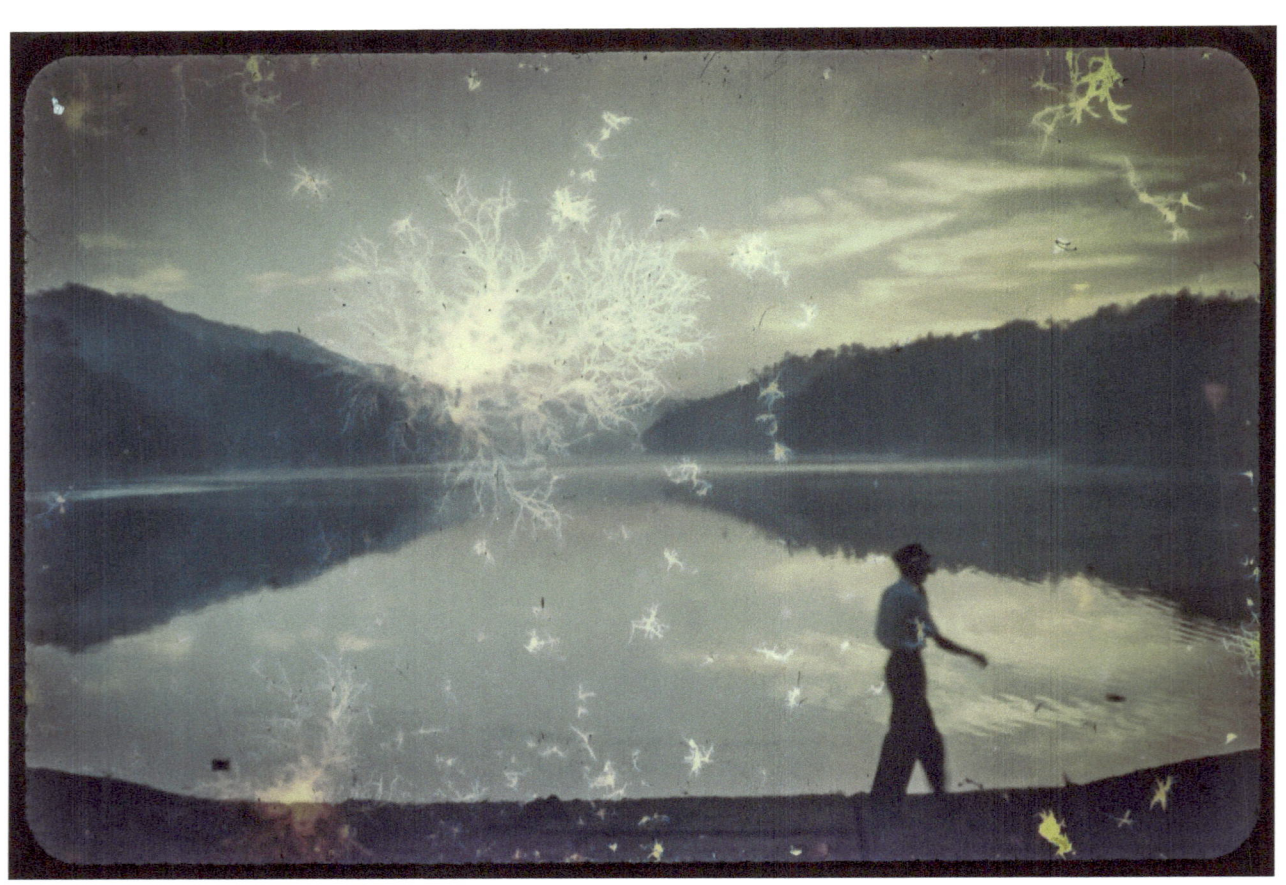

"I was surrounded by a tremendous flash and blast at the same time. I couldn't breathe. I was knocked to the ground and became unconscious. When I awoke I thought it was already night because I could not see anything. There was no sound at all."[3]

Keiko Ogura

"Suddenly I was facing a gigantic fireball. It was at least five times bigger and ten times brighter than the sun. It was hurtling directly towards me, a powerful flame that was a remarkable pale yellow, almost the color of white. The deafening noise came next. I was surrounded by the loudest thunder I had ever heard. It was the sound of the universe exploding."[4]

Shinji Mikami

"A nameless dread filled me whenever I wondered what type of bomb the ball of fire had been or what its scientific effects might be."[5]

Masuji Ibuse

"At 8:30 on a summer morning it was as dark as a half-moon night. In a while flames began to burst out of buildings. They spread steadily until the area around us was a sea of fire."[6]
 Eizo Nomura

"I had no understanding of what could have caused everything around me to change in just one instant. . . something truly different, something nothing to do with war. . . the newspaper reported that a single moment turned everything into the fiery hell foretold by Buddhism, but whoever wrote that was thinking in conventional terms. . . In fact we were invaded by a calm so complete that one would have thought that every living thing had died at once."[7]
 Yoko Oda

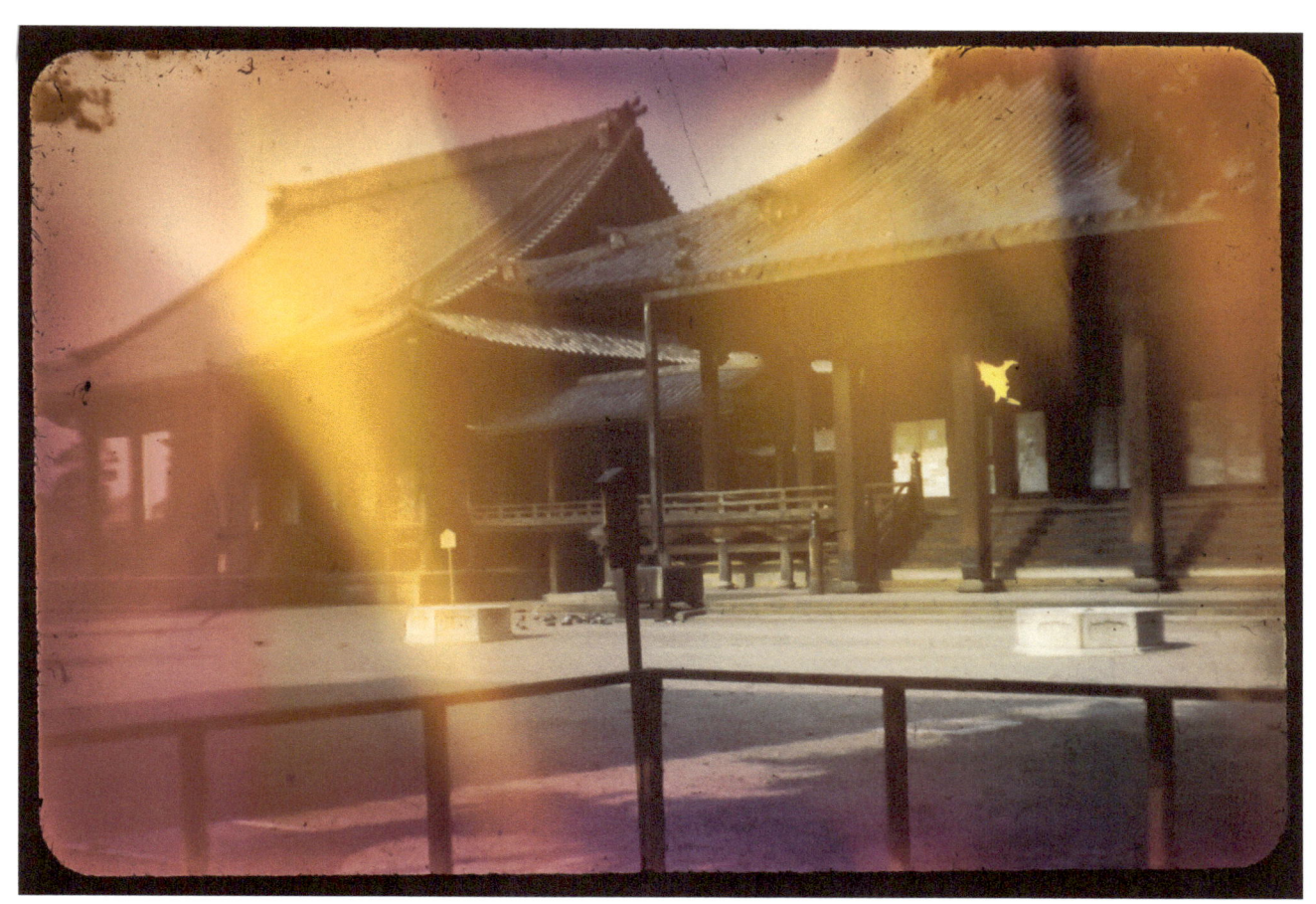

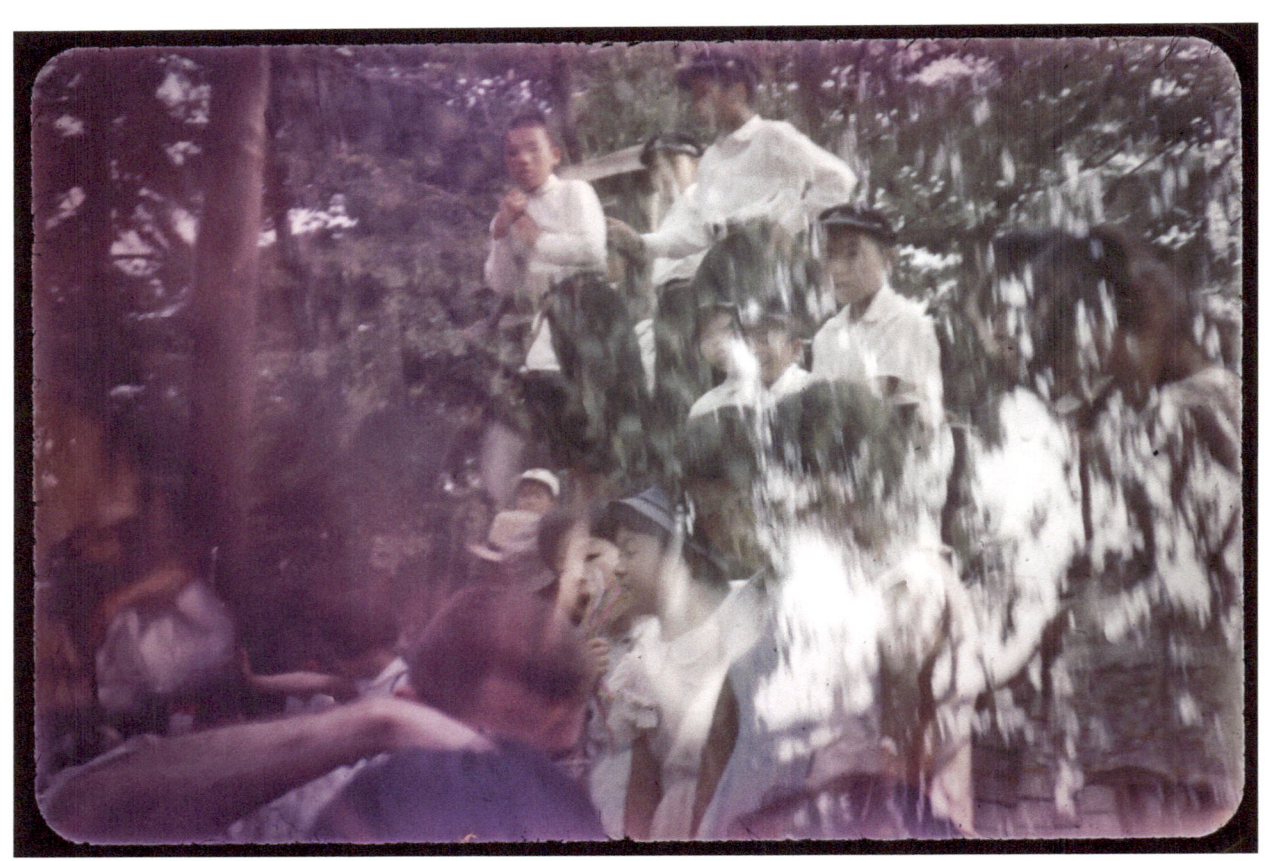

"As others, startled by the brilliant moment of light and the explosion like that of distant thunder, raised their heads to gaze with eyes of awe at the beauty of the strange mushroom cloud silently billowing high in the blue skies, in another small corner of Hiroshima I was a traveler traveling somewhere between the land of the living and the land of the dead."[8]

<div style="text-align: right;">Matsu Katsutoshi</div>

"I could not rescue the children trapped in the school house being engulfed in flames. One little girl was almost out—I could have put my cheek next to hers and pulled her out except for the arm pinned under a pillar. I told them in my heart 'you'll be safe from harm soon' and placed my hands together in prayer."[9]

<div style="text-align: right;">Yoshinori Kato</div>

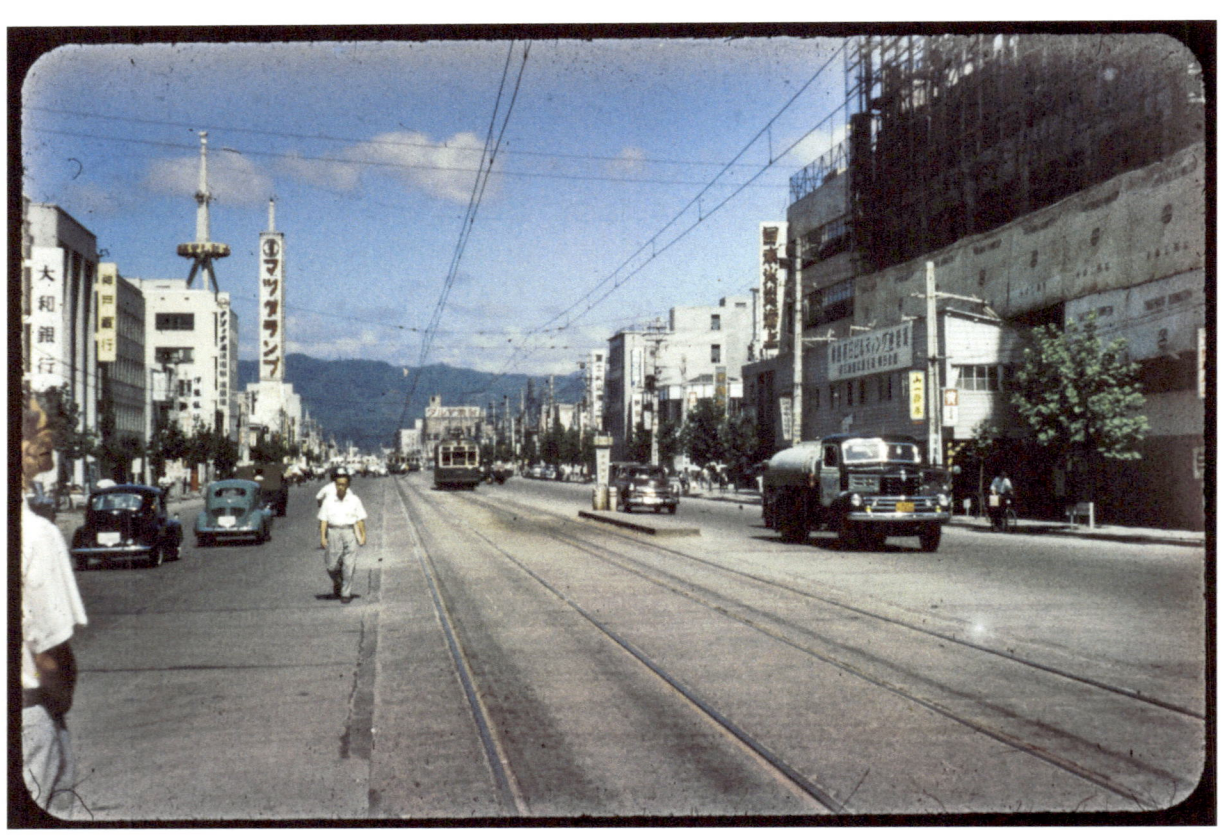

"As I got up from my prone position, the first thing to meet my gaze was a great, an enormous, column of cloud. In its texture it reminded me of cumulonimbus clouds I had seen in photographs taken after the Great Kanto Earthquake. But this one trailed a single thick leg beneath it and reached far up into the heavens. Flattening out at its peak, it swelled out fatter and fatter like an opening mushroom. . . the head of the mushroom would billow out first to the east, then to the west, then out to the east again; each time some part or other of its body would emit a fierce light in ever- changing shades of red, purple, lapis lazuli or green. The mushroom cloud was really shaped more like a jellyfish than a mushroom. Yet it seemed to have a more animal vitality than any jellyfish, with the leg that quivered and its head that changed color as it sprawled out slowly toward the southeast, writhing and raging as though it might hurl itself on our heads at any moment. It was an envoy of the devil himself I decided: who else in the whole wide universe would have presumed to summon forth such a monstrosity? The bomb, indeed, had been of a power beyond the mind of man to concieve."[10]

<div align="right">Masuji Ibuse</div>

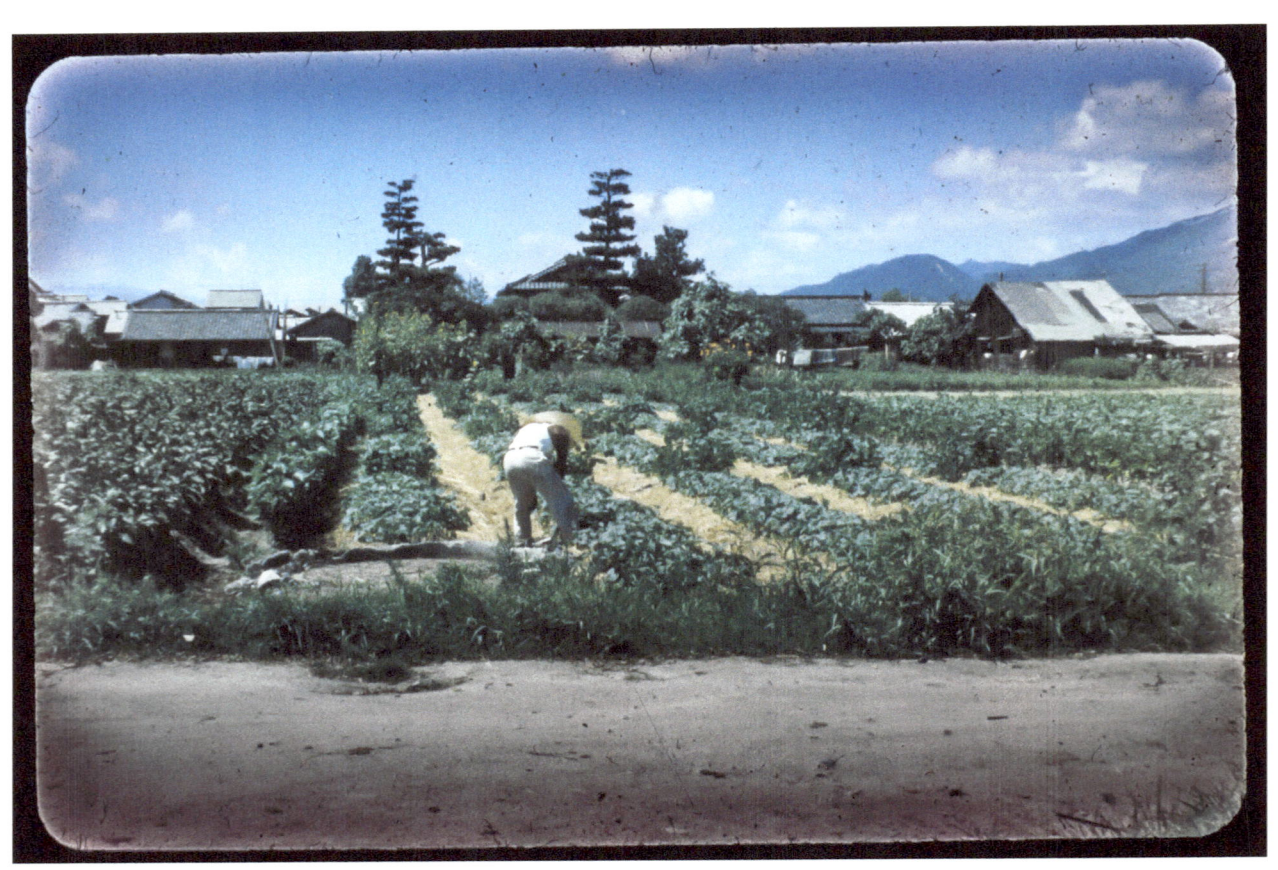

"A shower of black rain fell at about 10 am. Thundery black clouds had borne down on us from the direction of the city and rain from them had fallen in streaks the thickness of a fountain pen. . . they made marks that would not come off, firmly stuck on the skin. They were not tar nor black paint but something of unknown origin."[11]

Masuji Ibuse

"After the atomic bombing black rain fell. My whole body was covered by something slimy like rain mixed with oil. The black clouds covering the sky filled the confused people fleeing the city with uncanny dread."[12]

Satoshi Yoshimoto

From a Hiroshima newspaper in the summer of 1958: "Over 90,000 A-Bomb victims are still suffering in Hiroshima. Last week the 16th victim to die this year was recorded. . . a farmer."

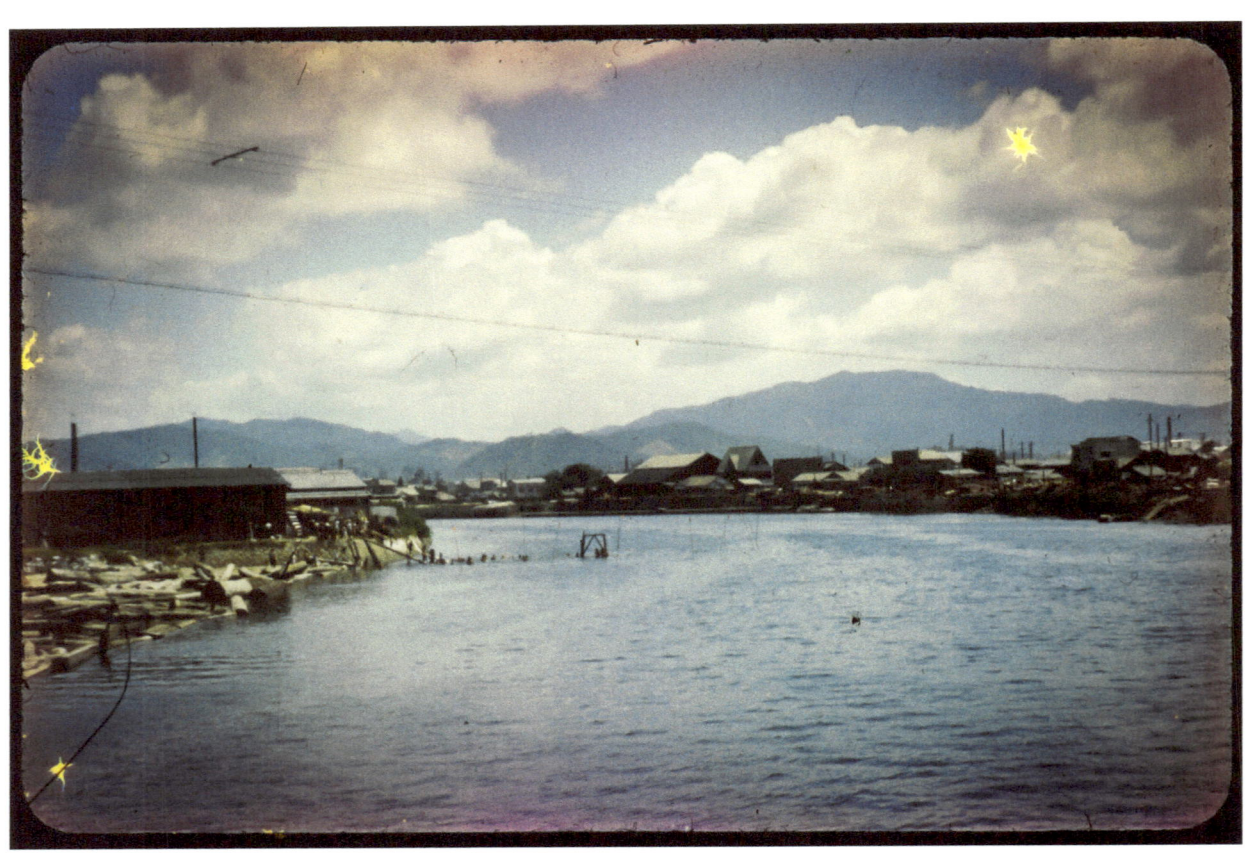

"My skin hung off my body in pieces like ragged clothes. I was badly burned on my right side and my left hand was also burned from the bomb. Fire was coming closer. We were told to run to the rivers when hit by air raids so people jumped into the rivers. So many bodies were floating in the river that I could not even see the water. Rivers were the only safe haven from the flames for survivors of the initial flash and blast. They became choked with floating corpses and the walking dead, like ghosts."[13]

<div align="right">Shizuko Abe</div>

"They must have jumped in the river to escape their sufferings. I think many were soldiers. The surface was covered with bloated, floating bodies of people who had died in the water. When I look at the riverbank, I can't help but remember how I felt then."[14]

<div align="right">Mashiko Nakata</div>

"Some managed to skirt the flames to get to the river only to collapse on the bank. Some writhed in agony and died before my eyes. Those still alive waded into the waves aiming for the other side. Countless victims were swept drowning down the river, while encroaching fires continued to force people into the water."[15]

<div align="right">Yoko Suga</div>

"A water spout suddenly gushed up. My co-worker and I were swept into it still clutching each other. I swallowed a huge amount of water and lost consciousness. When I came to minutes later, I had been dashed down on the river bank."[16]

<div align="right">Hiroko Fukukda</div>

"On the riverbank I saw figures that seemed to be from another world. Ghost like, their hair falling over their faces, their clothes ripped to shreds, their skin hanging. A cluster of these persons was moving wordlessly towards the outskirts."[17]

<div align="right">Yoshimura Kichisuki</div>

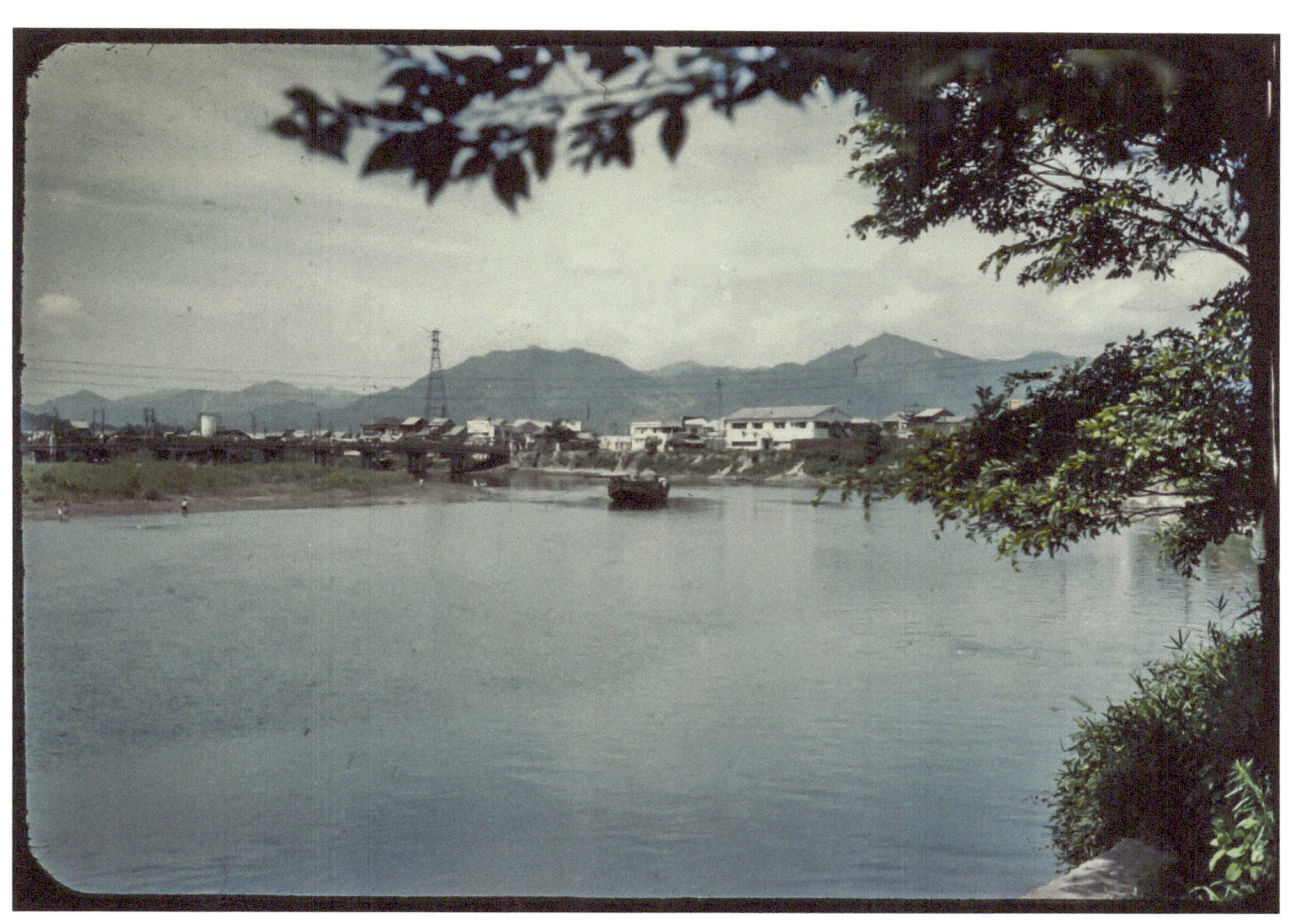

"All day, people poured into Asano Park. This private estate was far enough away from the explosion so that its bamboos, pines, laurel and maples were still alive, and the green place invited refugees. . . the estate's exquisitely precise rock gardens, with their quiet pools and arching bridges, were very Japanese, normal, secure. . .

"When Mr. Tanimoto. . . reached the park, it was very crowded, and to distinguish the living from the dead was not easy, for most of the people lay still, with their eyes open. . . the silence in the grove by the river where hundreds of gruesomely wounded suffered together was one of the most dreadful and awesome phenomena of his whole experience."[19]

<div style="text-align: right;">John Hershey</div>

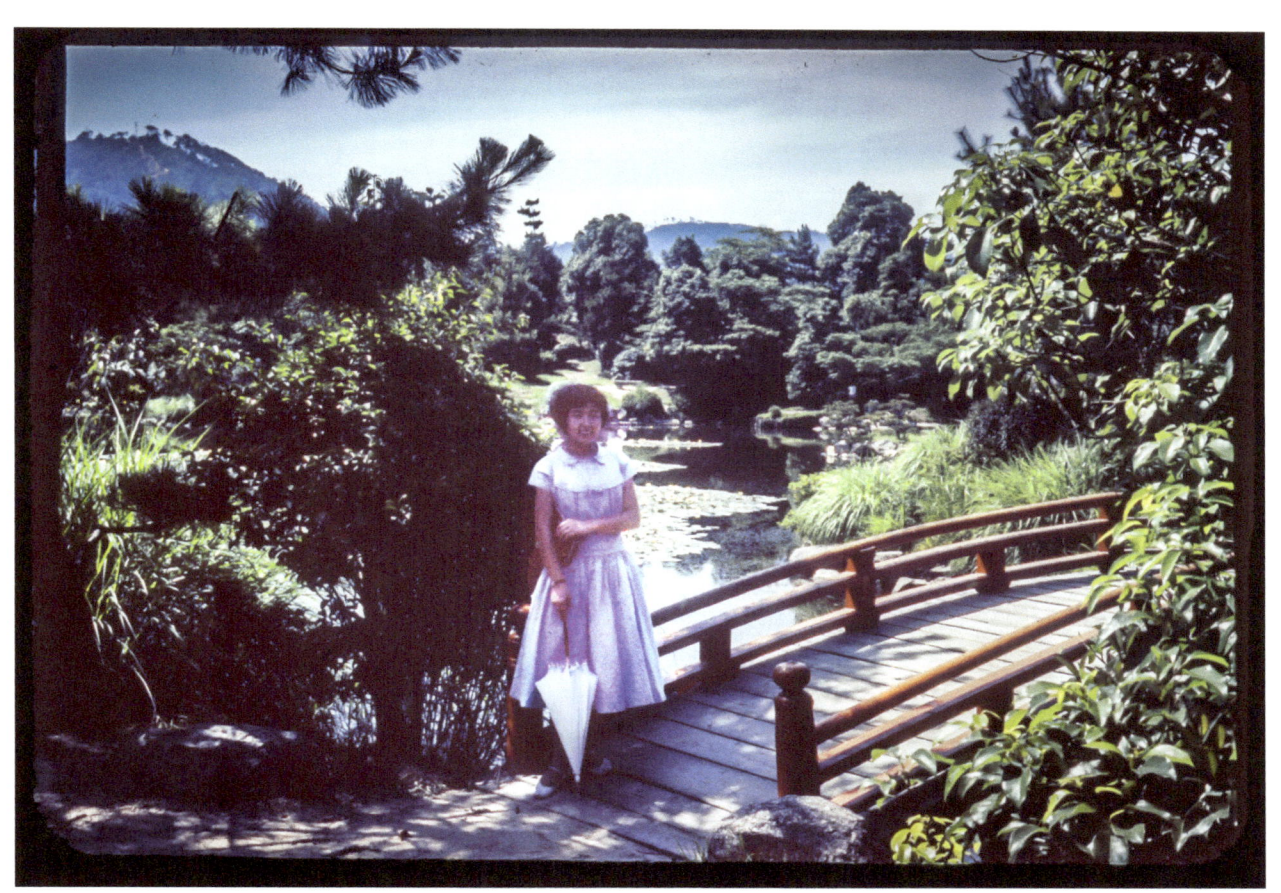

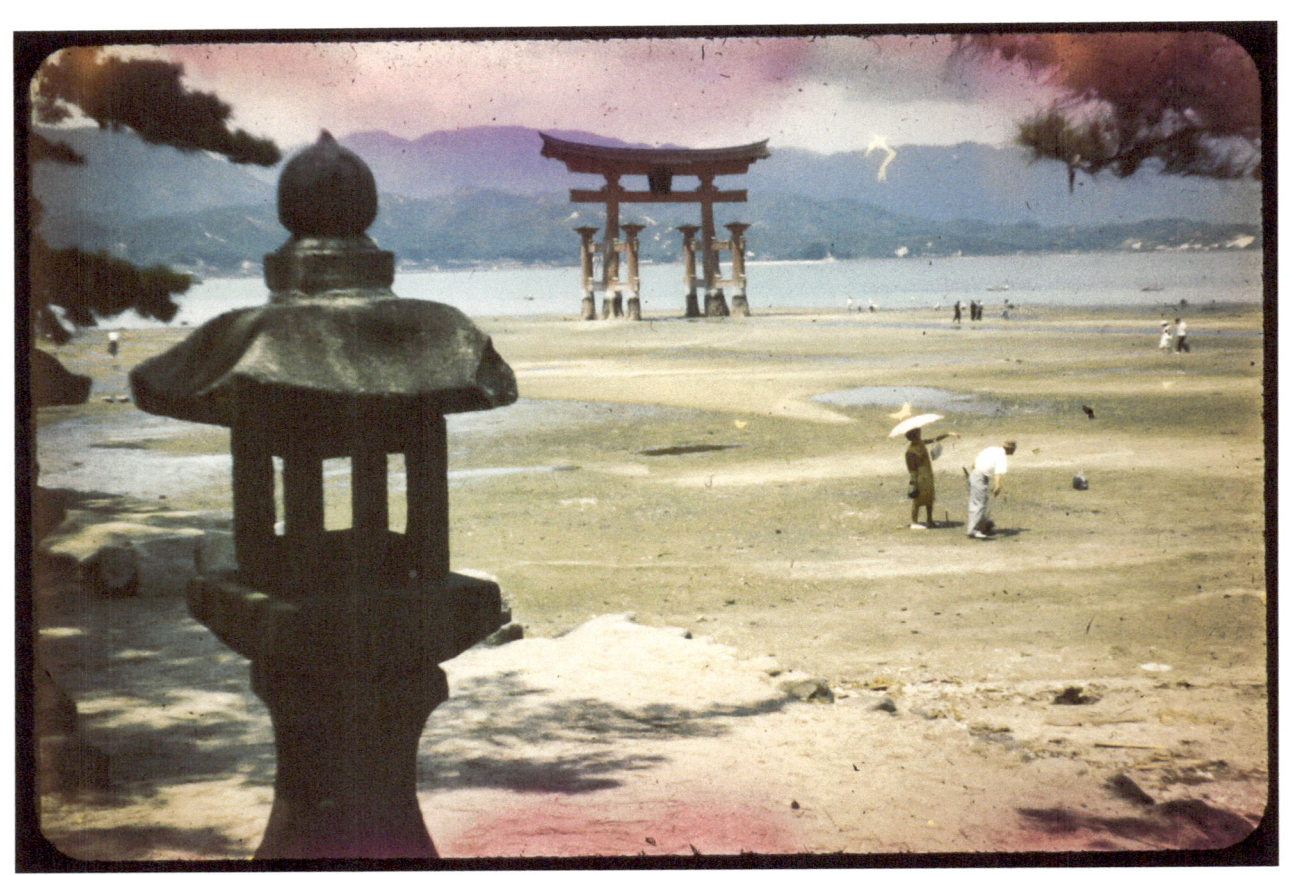

"Nothing stood on the scorched waste at the center of the city save the skeletons of a few buildings. Apart from these the only thing that met the eye was a litter of carbonized timbers and fragments of tile. The occasional black and white speck moving in the wilderness would be a human being searching, as likely as not, for the remains of a relative or friend. It was a scene of unremitting desolation."[19]

<div align="right">Masuji Ibuse</div>

During the final months of World war II Hiroshima Castle served as the headquarters of the Second General Army with the Fifth Division stationed there to deter the projected Allied invasion of the Japanese mainland. The castle was destroyed in the atomic bomb blast and for many years it was believed that the castle structure was blown away by the explosion that destroyed Hiroshima. But newly discovered evidence suggests the explosion only destroyed the lower pillars of the castle and the rest of it collapsed as a result.

The present tower, constructed of concrete was completed in 1958.

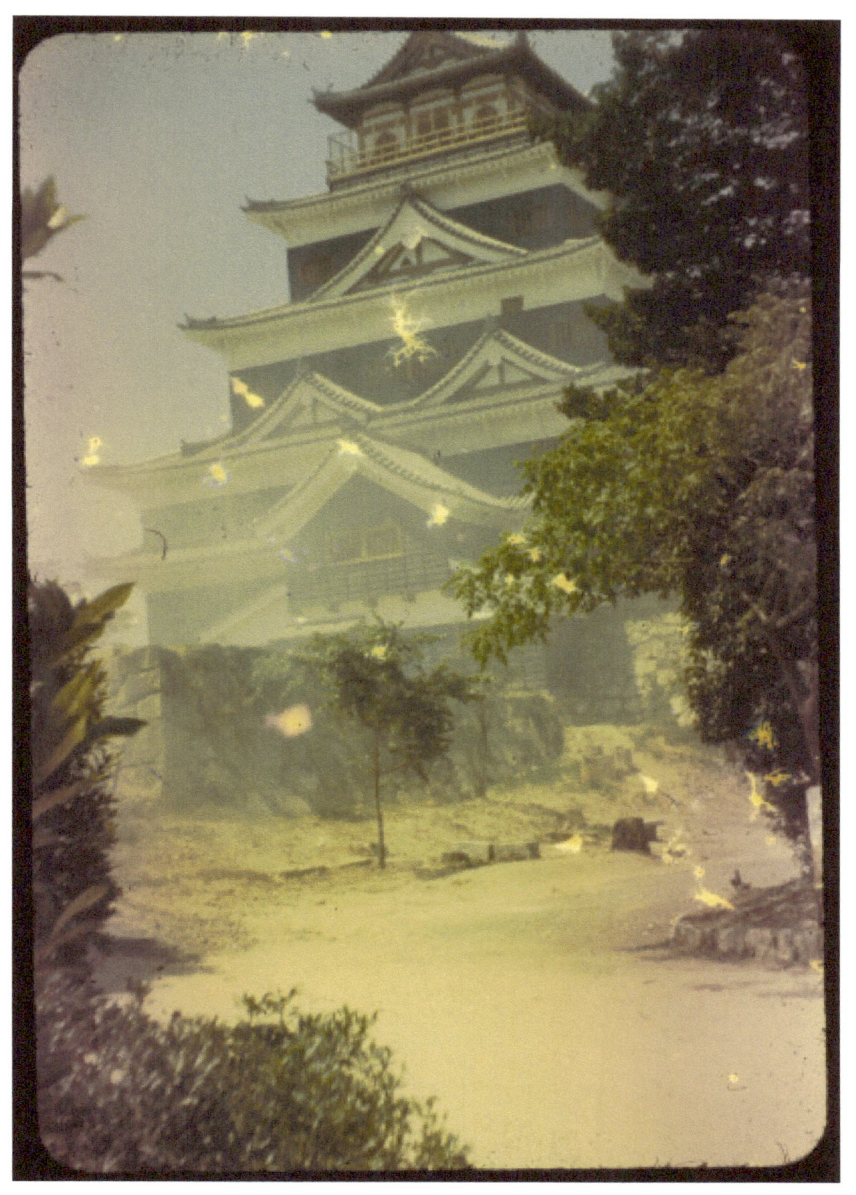

"Seventy-one years ago, on a bright cloudless morning, death fell from the sky and the world was changed. A flash of light and a wall of fire destroyed a city and demonstrated that mankind possessed the means to destroy itself.

"The memory of the morning of August 6th 1945 must never fade. That memory allows us to fight complacency. It fuels our moral imagination. It allows us to change.

"Technological progress without an equivalent progress in human institutions can doom us.

"The scientific revolution that led to the splitting of an atom requires a moral reolution as well.

"Hiroshima and Nagasaki are known not as the dawn of atomic warfare but as the start of our own moral awakening."[20]

<p align="right">President Barack Obama
Hiroshima, May 2016</p>

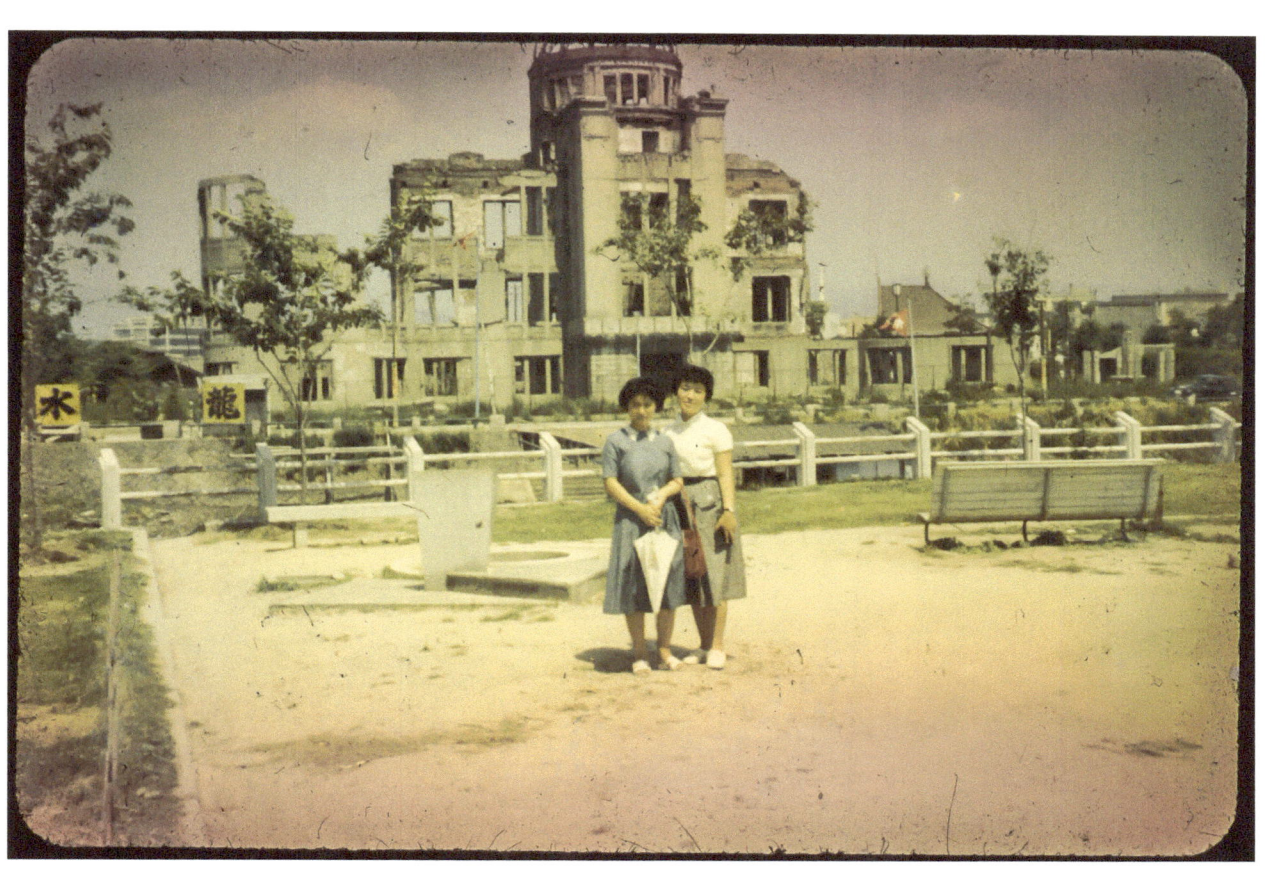

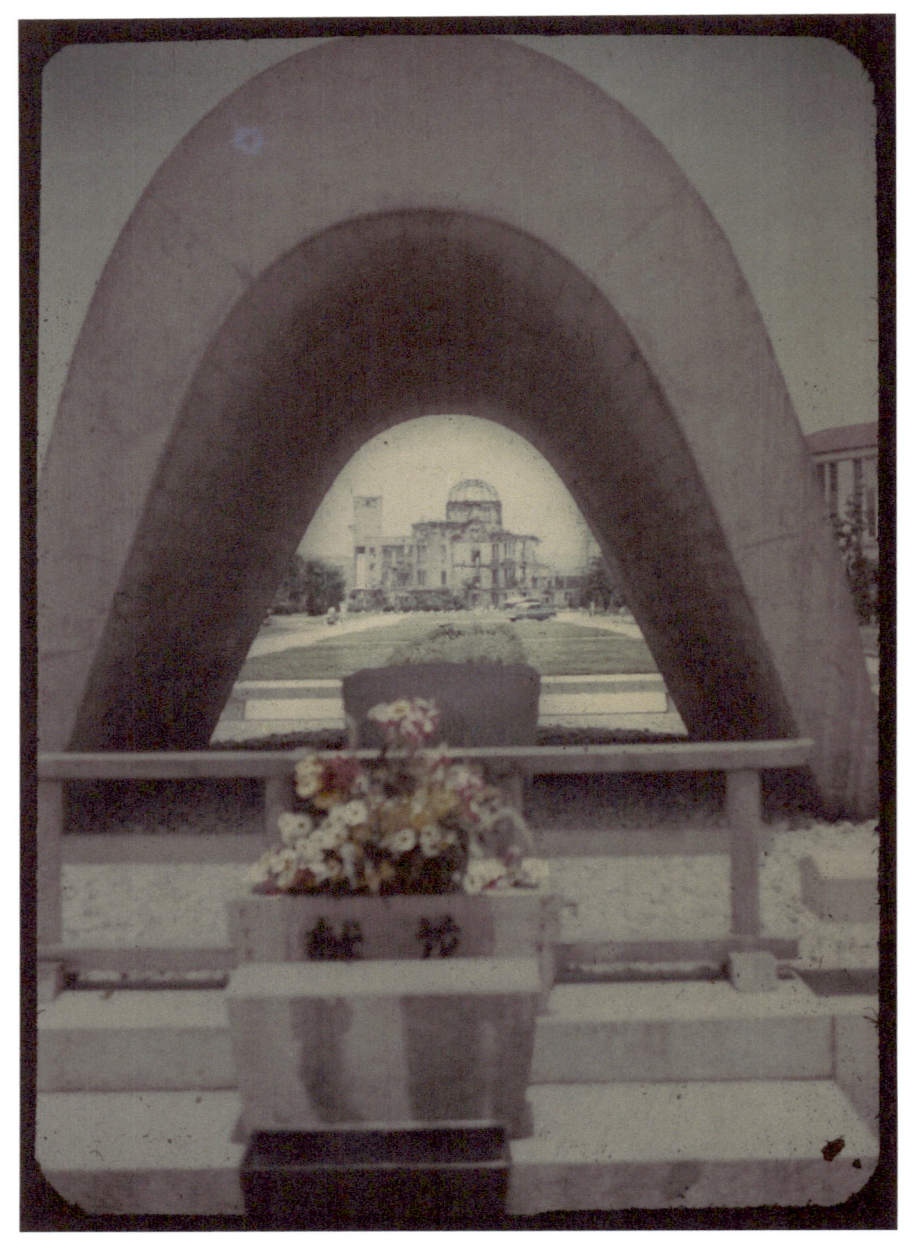

"The unleashed power of the atom has changed
everything save our mode of thinking." [21]
Albert Einstein

"This isn't a bomb at all. The word 'bomb' carries with it a
completely inaccurate picture of what this thing does."[22]
General Thomas F. Farrell

" Such a weapon has the power to make everything
into nothing." [23]
John Whittier Treat

"Give me back my father.
Give me back my mother.
Give me back the old people. Give me back the children.
Give me back myself. And those people Joined to me. Give
them back. Give me back mankind.
Give me peace,
A peace that will not shatter
As long as man, man is in the world."[24]

Toge Sankichi—the most famous atomic bomb poem, carved
into stone in the Peace Park.

The Children's Peace Monument is dedicated to Sadako Sasaki and the thousands of children who also died from the atomic bombing of Hiroshima.

Sadako died of leukemia from radiation poisoning ten years after her exposure. She was 12 years old and while in the hospital, with the help of her classmates, had folded a thousand paper cranes. Japanese legend promises that if a person folds a thousand cranes one wish will be granted. Sadako's wish was to have a world free of nuclear weapons.

Of her cranes she said: "I will write 'peace' on your wings and you will fly all over the world."

Today her monument is full of paper cranes sent from all over the world, yet nuclear weapons continue to exist.

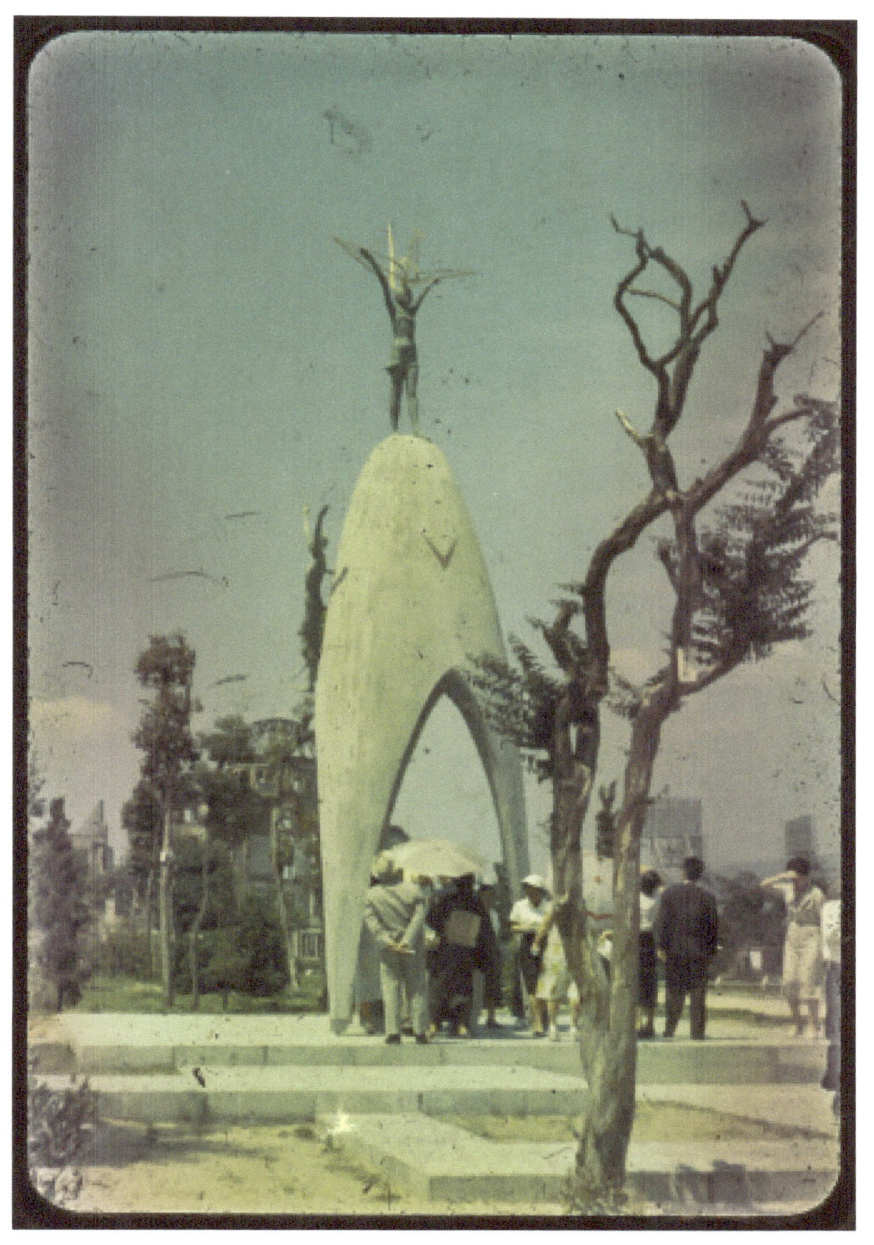

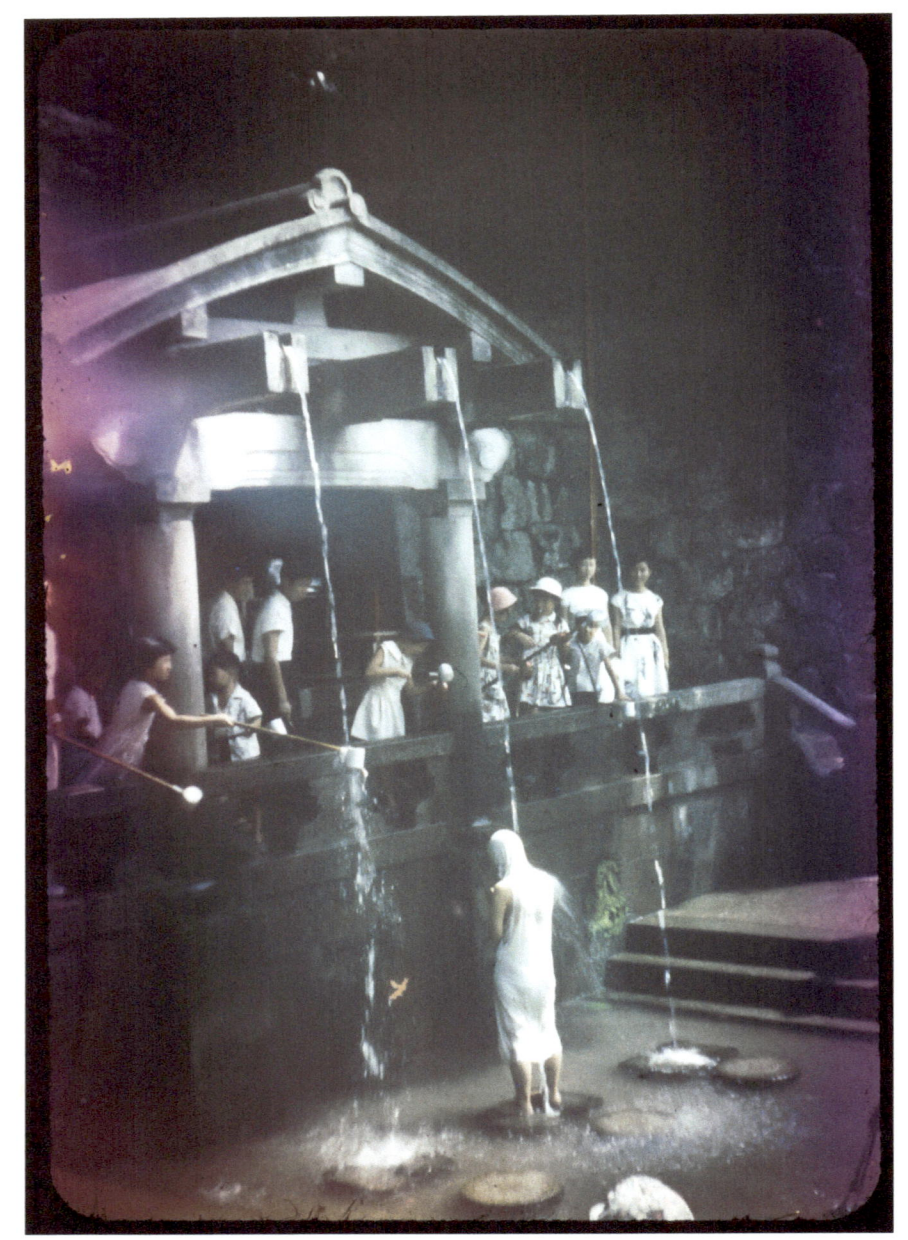

WE SHALL NOT REPEAT THE EVIL
Words engraved on the Memorial Cenotaph

REFERENCES

Hershey, John, *Hiroshima* (Alfred Knopf, inc. 1946, 1985).

Hiroshima Peace Memorial Museum, *A-Bomb Drawings by Survivors* (Iwanami Publishing, 2007).

Ibuse, Masuji, *Black Rain* (Kodansha International ltd. 1969).

Treat, John Whittier, *Writing Ground Zero: Japanese Literature and the Atomic Bomb* (University of Chicago Press, 1995).

Acknowledgements

1. Treat, John Whittier, *Writing Ground Zero: Japanese Literature and the Atomic Bomb* (University of Chicago Press, 1995), 5.
2. Ogura, Keiko, *Hiroshima: The Human Cost and the Hisotrical Narrative*, BBC News 4 August 2015. wwwbbc.com/news/world-asia-33754931.(This article has been removed following a complaint partially upheld by the BBC Trust.)
3. Mikami, Sinji, Ibid.
4. Ibuse, Masuji, *Black Rain* (Kodansha Internaational Ltd. 1969, 87).
5. Ibuse, Ibid. 254.
6. Nomura, Eizo, *Atomic Bomb Drawings by Survivors* (Iwanami Publishing 2007), 47.
7. Kato, Yoshinori, Ibid. 114.
8. Ibuse, Black Rain 54.
9. Katsutoshi, Matsu, Treat 137.
10. Ota, Yoko, Treaat 210.
11. Ibuse, *Black Rain* 34.
12. Yoshimoto, Satoshi, *Atomic Bomb Drawings*, 30.
13. Abe, Shizuko, *When Time Stood Still*, BBC News, 23 July 2014, www.bbc.com/news/magazine-28392047.
14. Nakata, Mashiko, *Atomic Bomb Drawings*, 46.
15. Suga, Yoko, Ibid. 24.
16. Fukkuda, Hiroko, Ibid. 25.
17. Yoshimura, Kichisuki, Ibid. 27.
18. Hershey, John, *Hiroshima* (first published by The New Yorker in 1946. For the 70th anniversary of the atomic bombing the full text was published online "in the conviction that few of us have yet comprehended the all but incredible destructive power of this weapon and that everyone might well take time to consider the terrible impllications of its use.")
19. Ibuse, *Black Rain*, 160.
20. Obama, Barak, *The New York Times*, 28 May 2016.
21. Kraus, Lawerence, Deafness at Doomsday, *New York Times*, 15 January 2013.
22. Treat 403.
23. Ibid. 137.
24. Ibid. 172.

"Hiroshima and Nagasaki were the initiation of a new phase of human history that we are still only beginning to inhabit, much less comprehend. . . .

Hiroshima is a mode of thought that transcends the fact of the weapons themselves and becomes the conscience of the world."

<div style="text-align: right;">John Whittier Treat</div>

Virginia Moffat Khuri

 I have been making photographic fine prints since 1977, first in London, England, and most recently on the East End of Long Island, New York. I began working solely in traditional black and white because as a teenager I fell in love with the black and white images in *The Family of Man*, and then I discovered the work of Alfred Steiglitz, Ansel Adams, Edward Weston, and Minor White. I was fortunate to attend the next to last workshop of Adams and later on studied with Minor White's student, Paul Caponigro. Always, what fascinated me was the magic of the darkroom and the chance there to translate three-dimensional reality into transcendent black and white images. Now I also use archival digital technology seeking a similar transformation but in subtle and finely detailed color. I have always used my camera not to illustrate or document the world before the lens, but to convey something of the quality of my particular individual experience of it.

 While in England I attended master classes at The Photographers Place in Derbyshire and earned a Masters Degree in Photography from De Montfort University in Leicester. I also became a Fellow of the Royal Photographic Society of Great Britain and was a founder member of the RPS Contemporary Group.

Also Available from Between Lines Books & Arts

Curtains: Windows on the Unreality We Live In

 A photographic journey exploring the hidden realities lurking in the folds of puddled curtains that the photographer found in windows of a central London office building.
 The photographer puts the curtain folds though simple transformations that result in strange apparitions and eerie landscapes.
 Legendary photographer Paul Caponigro has dubbed the curtain series "innuendos for the eye." The photographer, John Briggs, wonders if perhaps the folds of the curtains he probes "suggests that even our familiar and objective reality is inherently unreal." In his introduction to the collection, Briggs discusses the curtain images in terms of the principles of abstract art.

The Art of the Fugue by J.S. Bach
Eric Lewis in Live Recordings of The Manhattan String Quartet and The New York Woodwind Quintet

 The Boston Globe called violinist Eric Lewis "a national treasure." *The New York Times* described his playing as "exquisitely phrased, heartfelt… a full rich sound made the bittersweet, almost desolate spirit of the music tangible."
 Lewis was founding member and long-time first violinist of the internationally acclaimed Manhattan String Quartet. Between 1981 and 1989 MSQ served in residence and as music directors for Music Mountain in Falls Village, Connecticut. On Sunday, July 14, 1985, at 4 p.m. Lewis and MSQ joined with the New York Wind Ensemble to perform the 21 extant fugues and canons of J.S. Bach's monumental *The Art of the Fugue*. This fine recording of that extraordinary evening has been recently restored in digital format. The recording captures the incomparable nuances and atmosphere of the live performance, and is being issued for the first time by Between Lines Books & Arts in two CDs.

SEE OUR WEBSITE AT WWW.BETWEENLINESBOOKS.COM
Remember: there is no "the" in our name.

www.ingramcontent.com/pod-product-compliance
Lightning Source LLC
Chambersburg PA
CBHW041124300426
44113CB00002B/56